W9-BMP-882

Entangled
COLORING BOOK

ANGELA PORTER

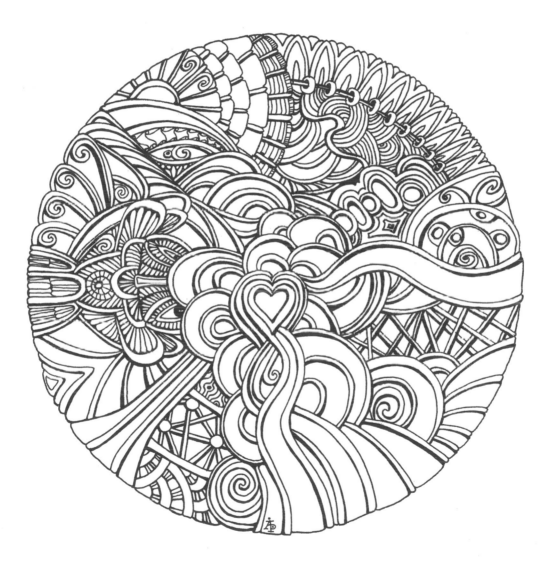

DOVER PUBLICATIONS, INC.
MINEOLA, NEW YORK

In this latest edition to Dover's *Creative Haven* series for the experienced colorist, thirty-one imaginative, sweeping designs feature free-form, repetitive patterns representing relaxation, tranquility, and creative expression. Interlocking and overlapping patterns offer the opportunity to experiment with different media and color techniques, and the perforated, unbacked pages make displaying your work easy!

Copyright

Copyright © 2015 by Angela Porter
All rights reserved.

Bibliographical Note

Entangled Coloring Book is a new work, first published by
Dover Publications, Inc., in 2015.

International Standard Book Number

ISBN-13: 978-0-486-79327-6
ISBN-10: 0-486-79327-3

Manufactured in the United States by RR Donnelley
79327315 2015
www.doverpublications.com

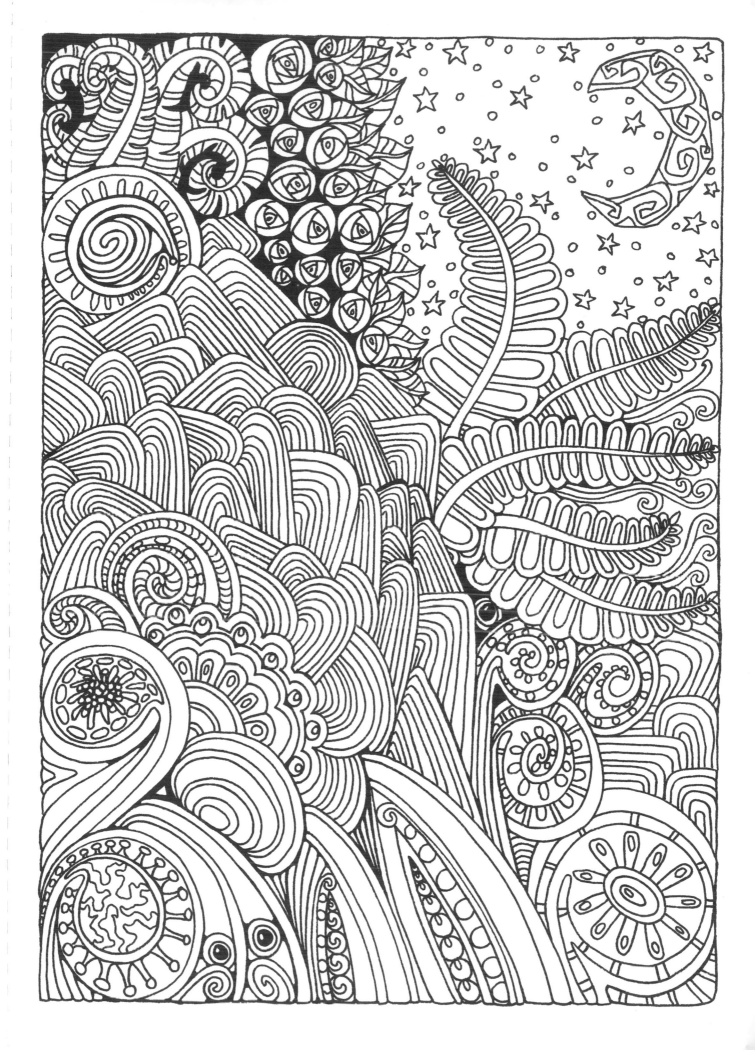

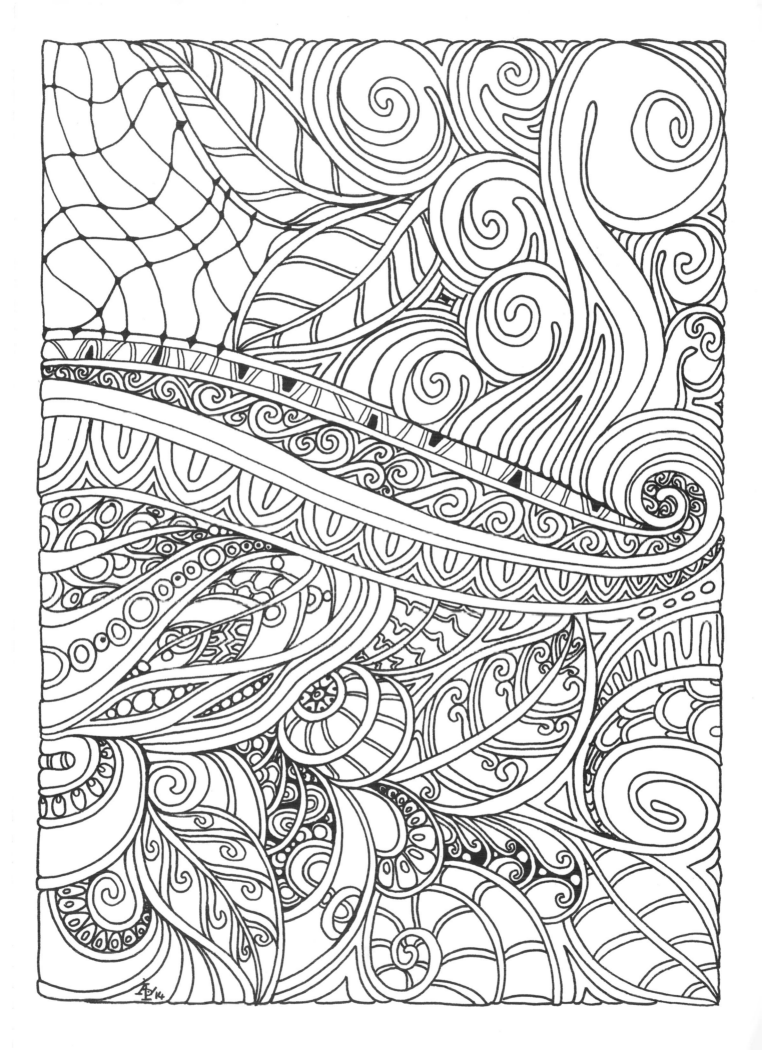

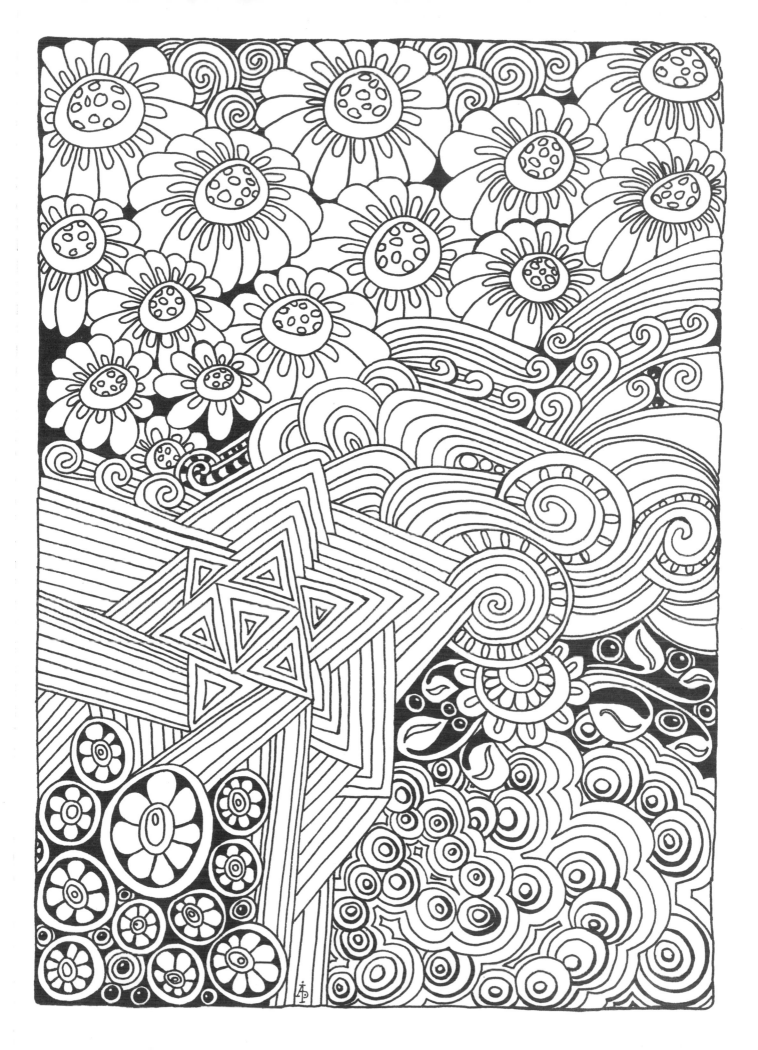

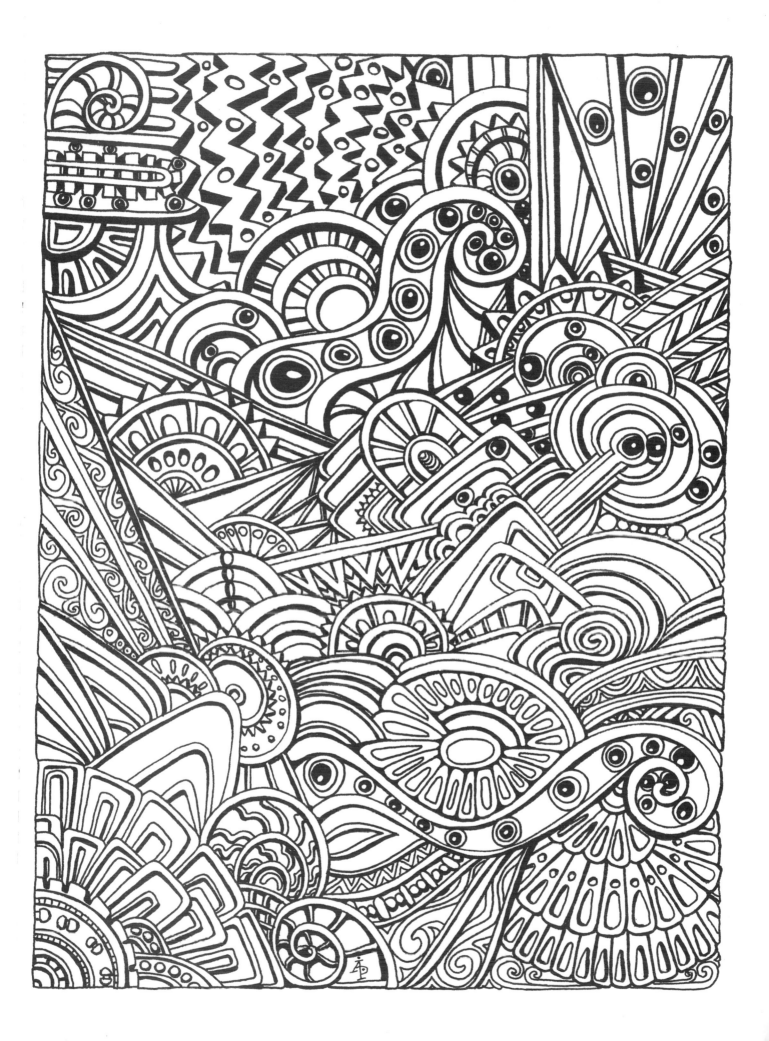

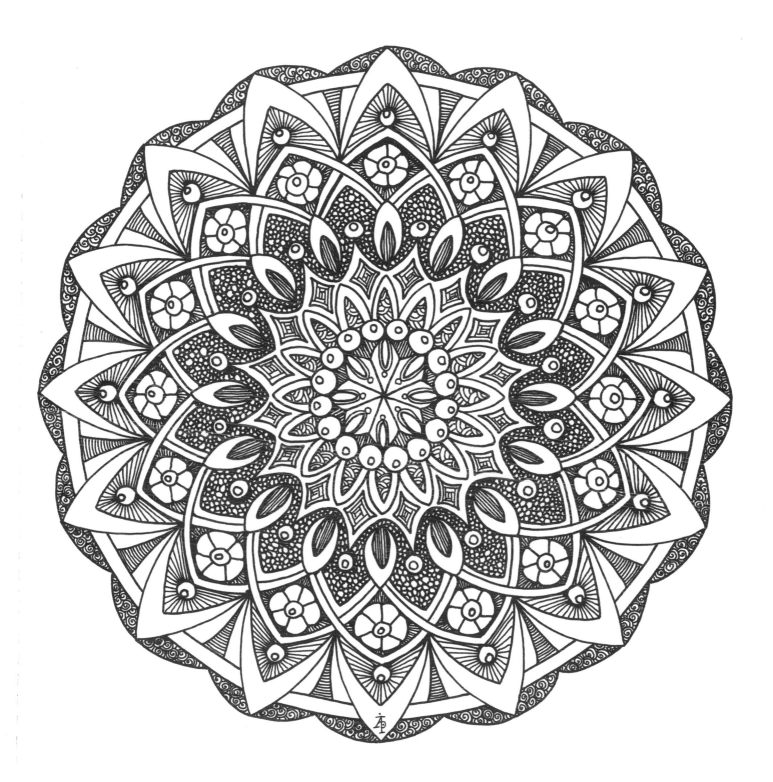

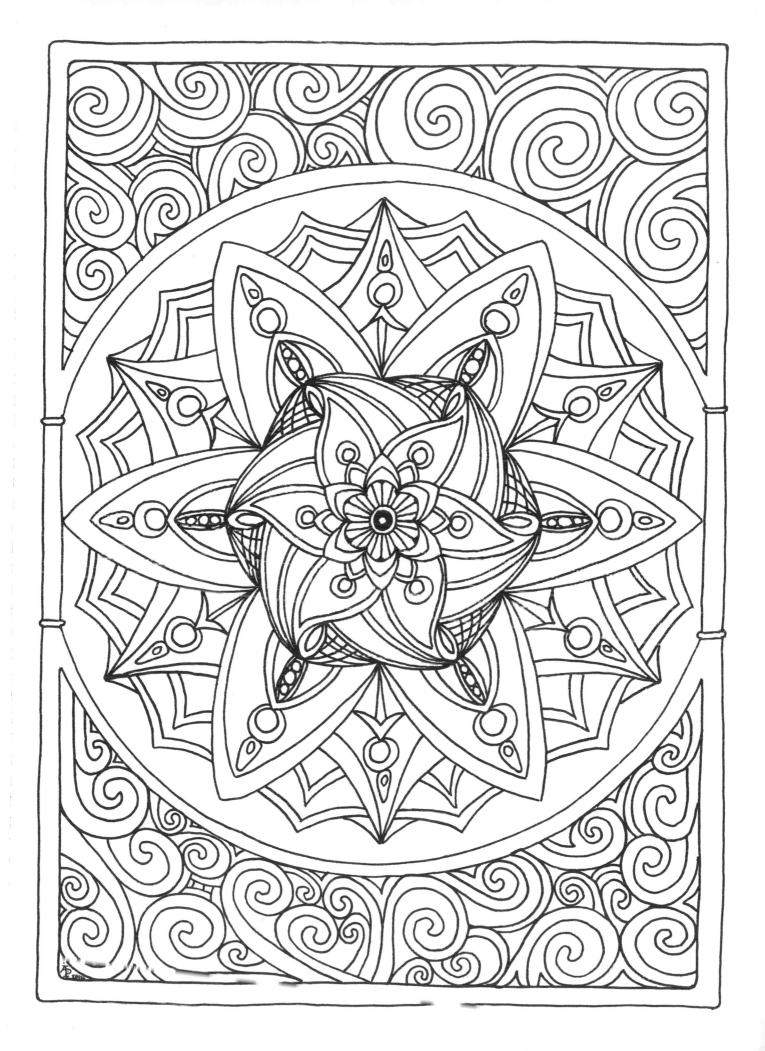

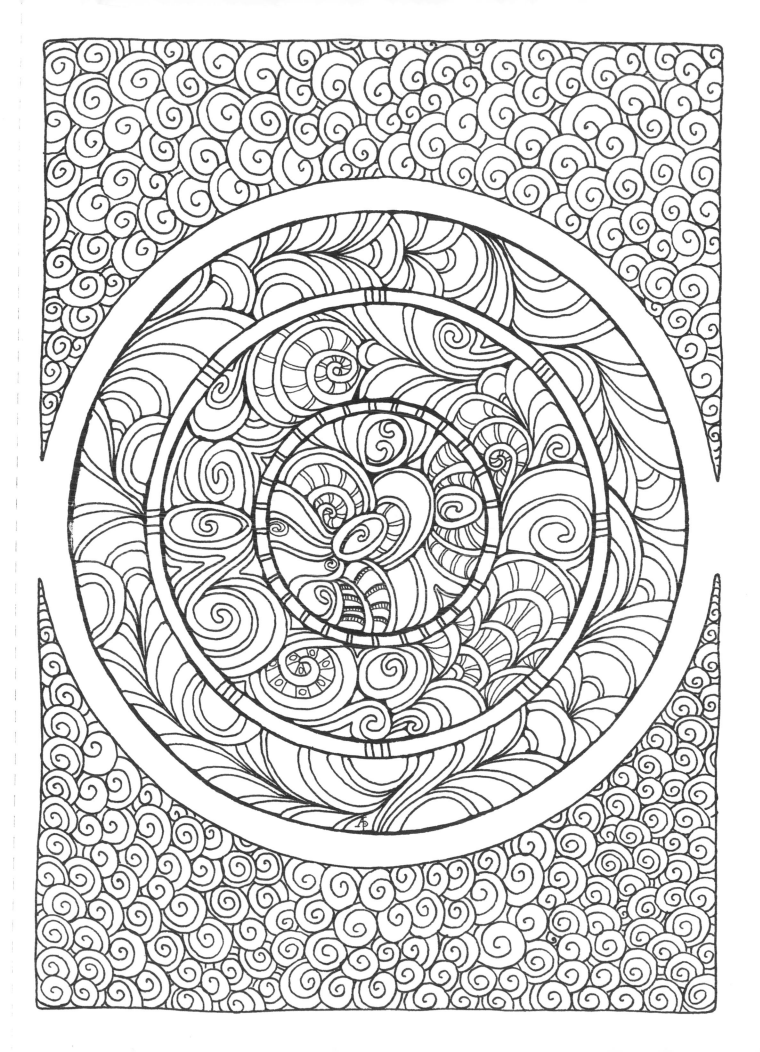

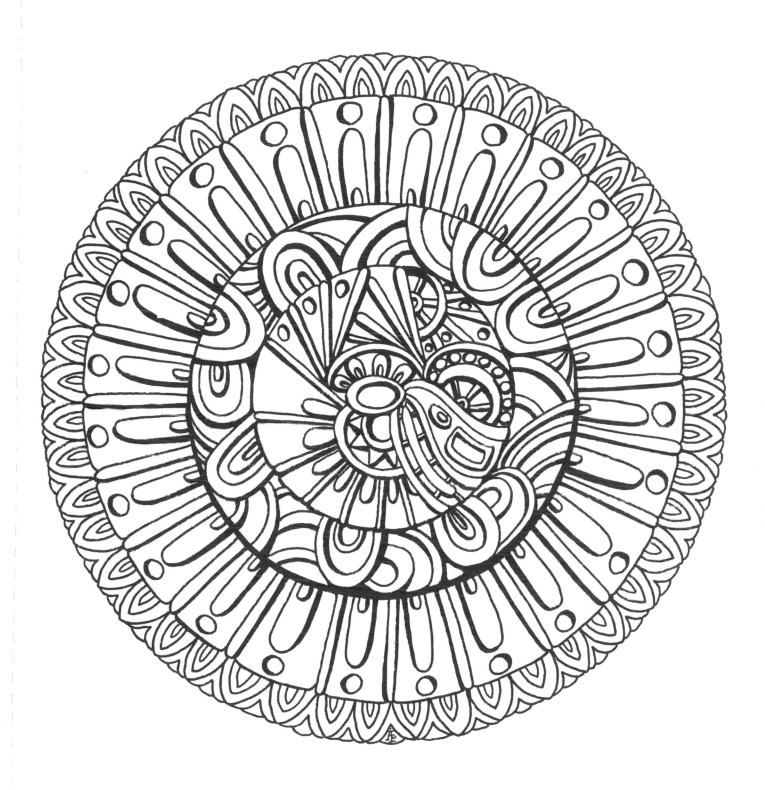

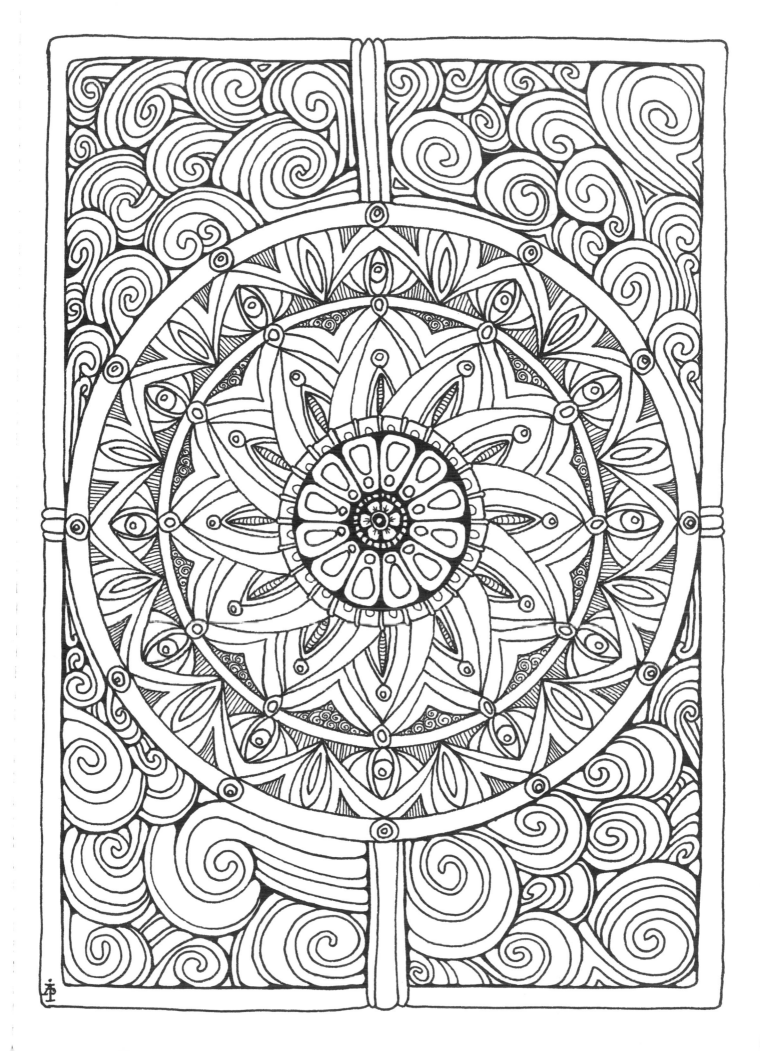

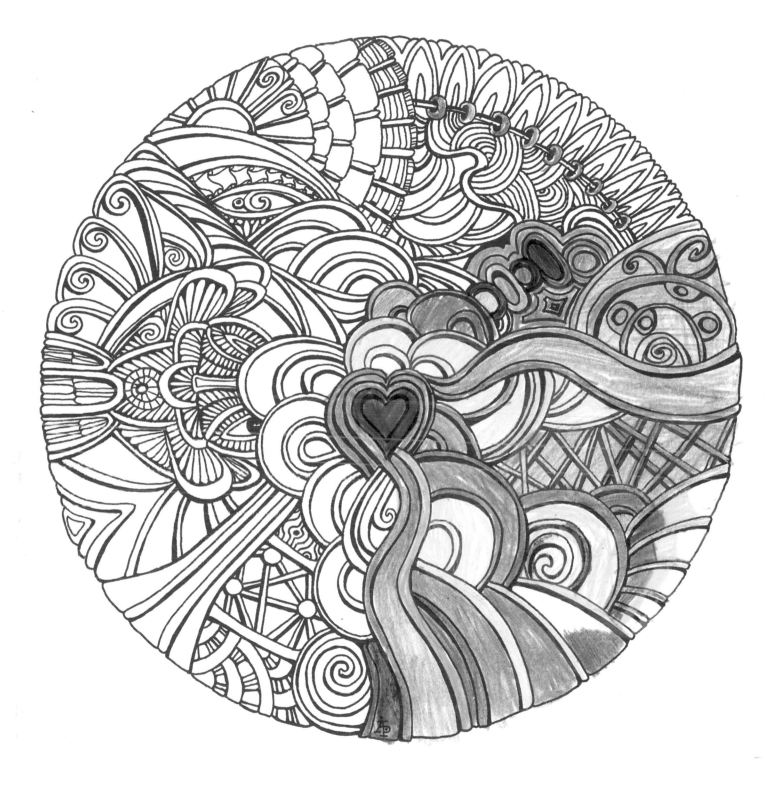

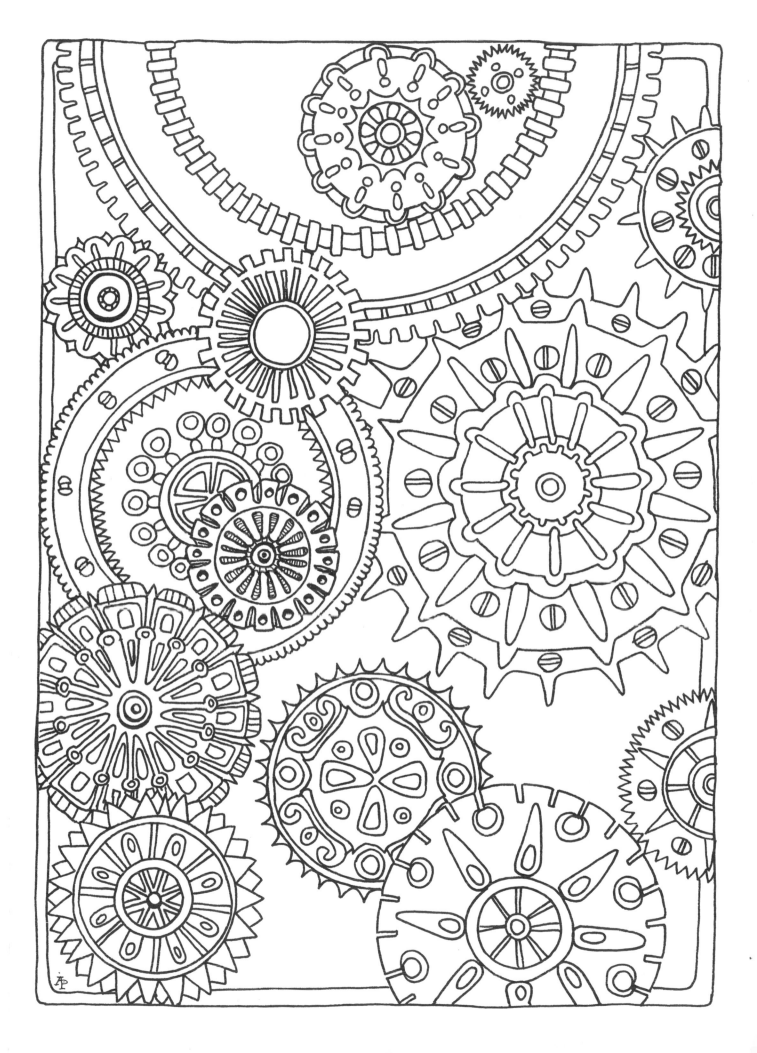

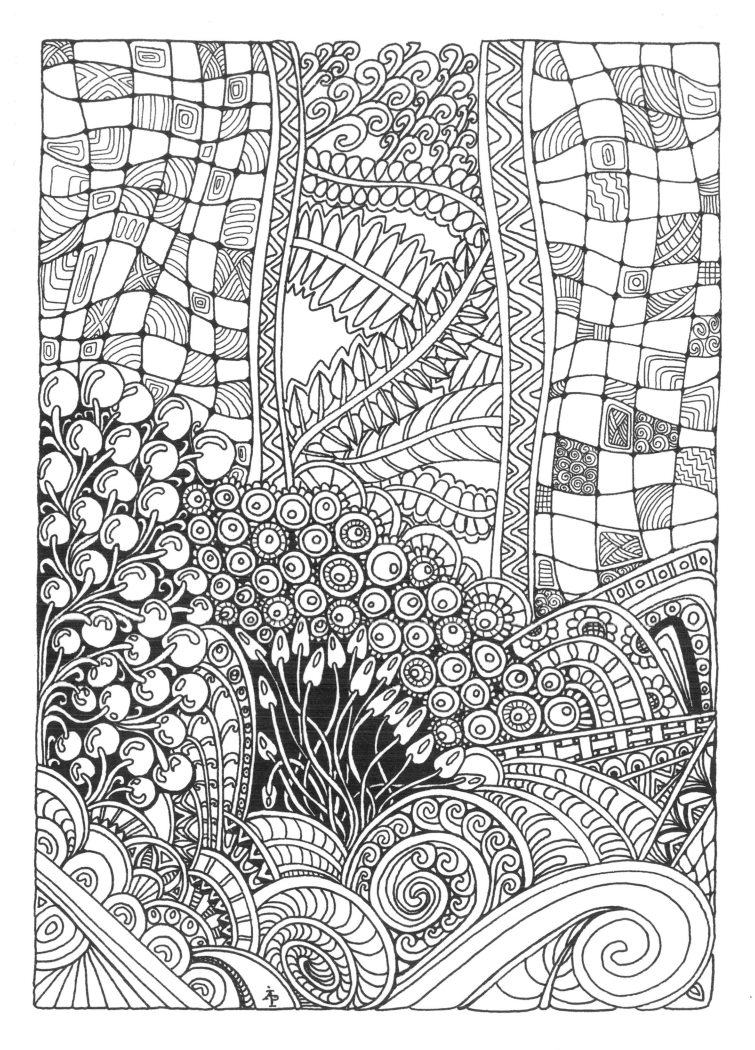

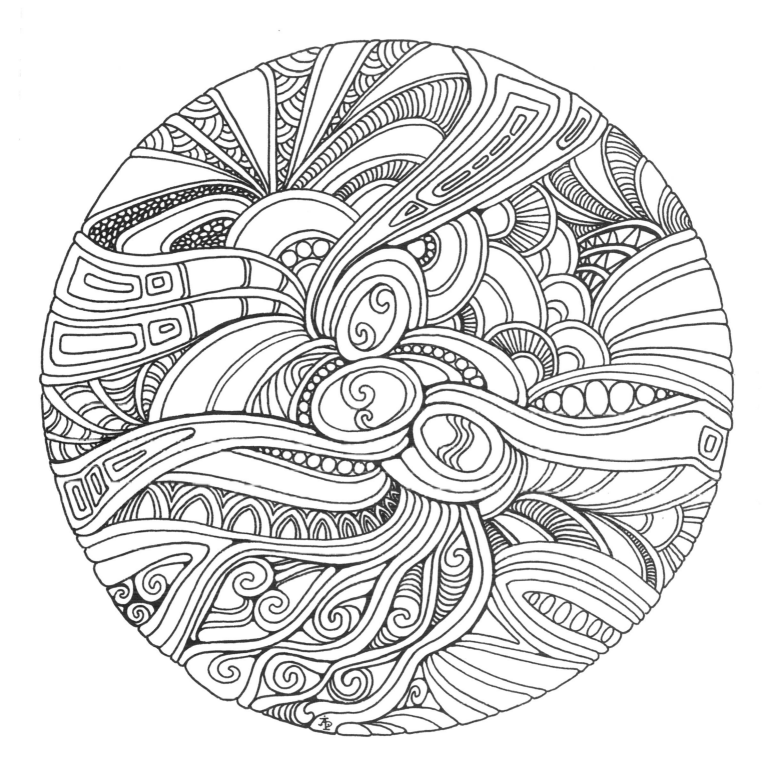

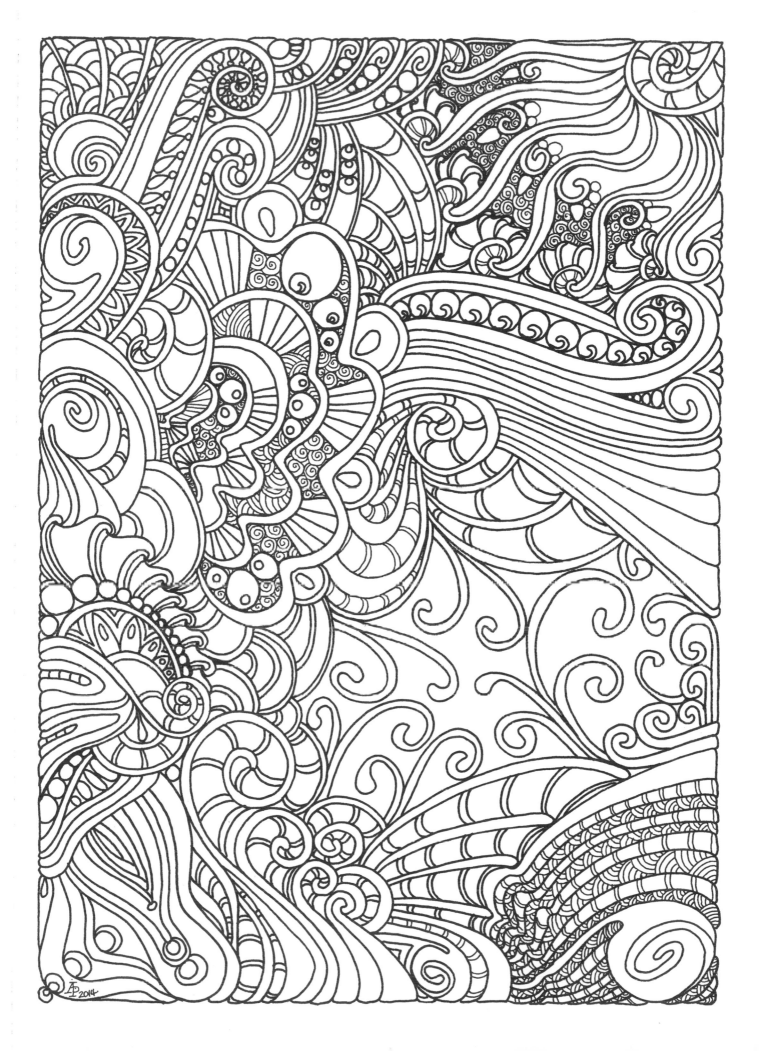

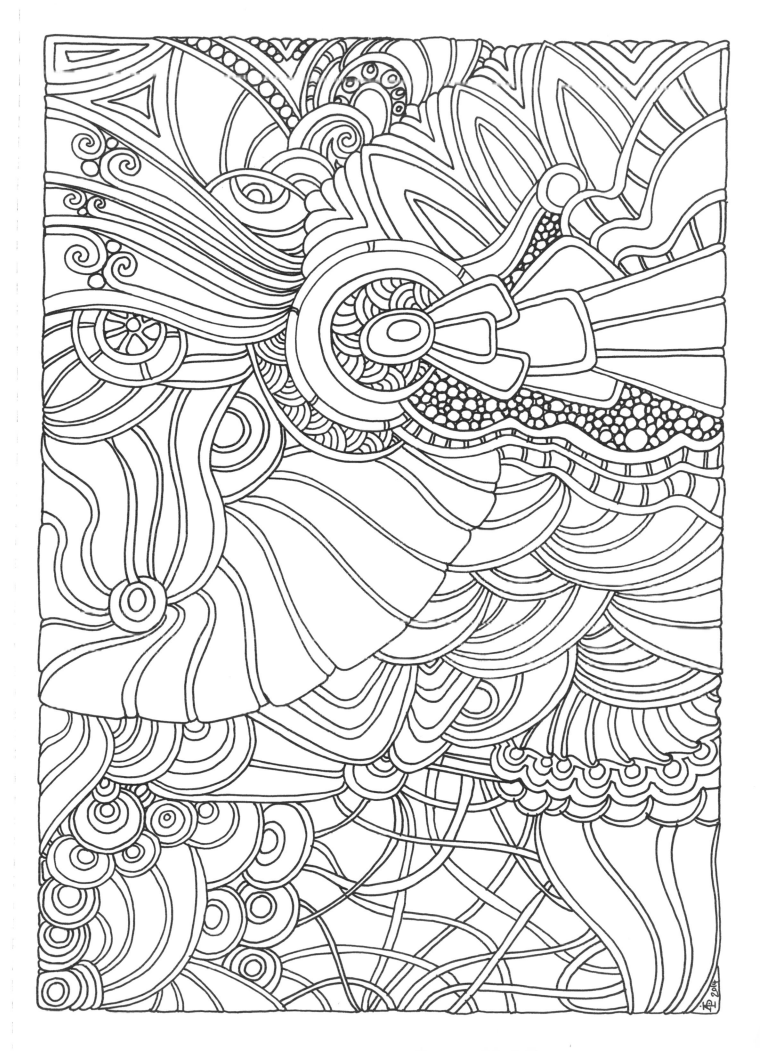

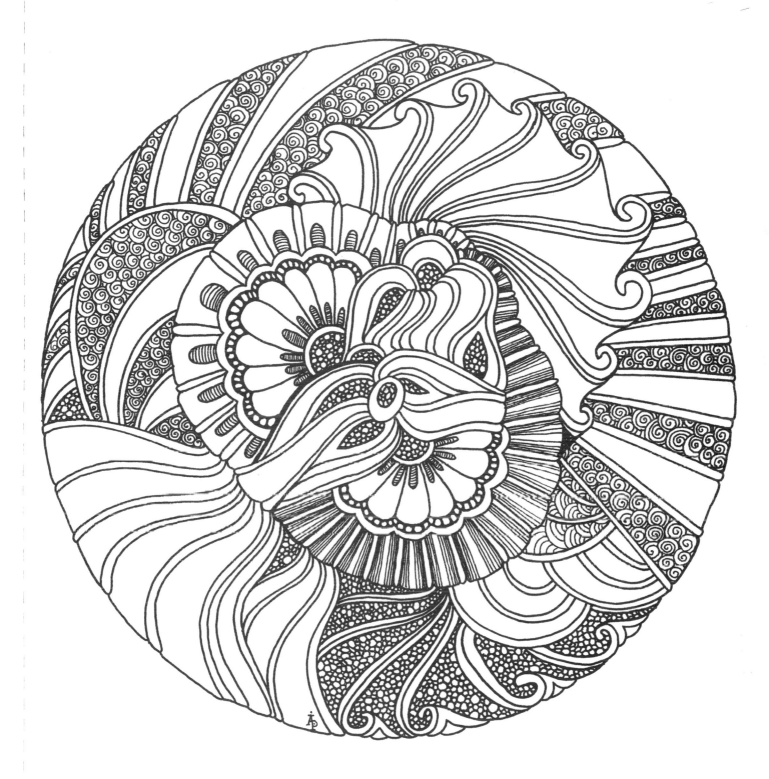

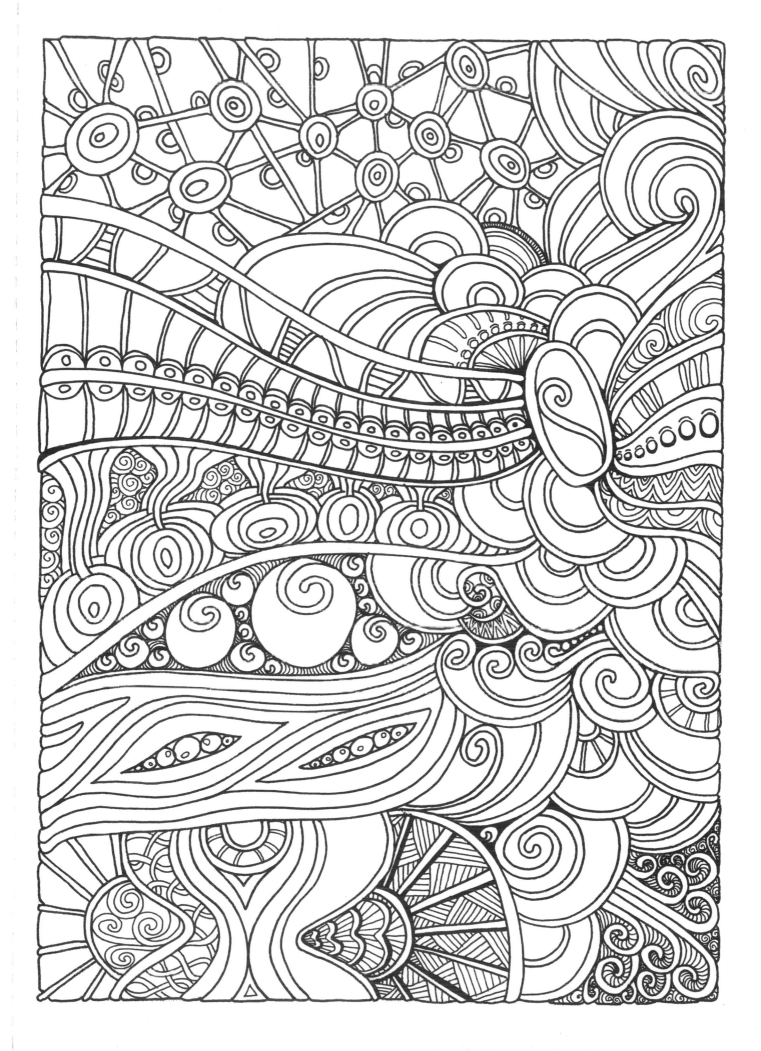

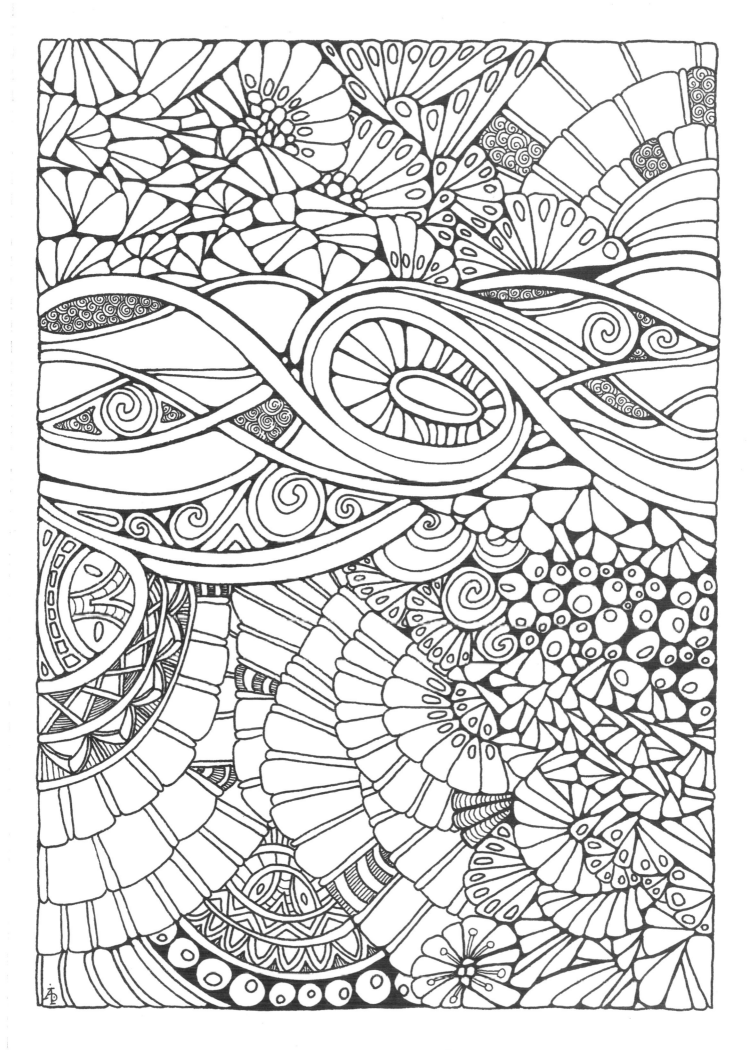

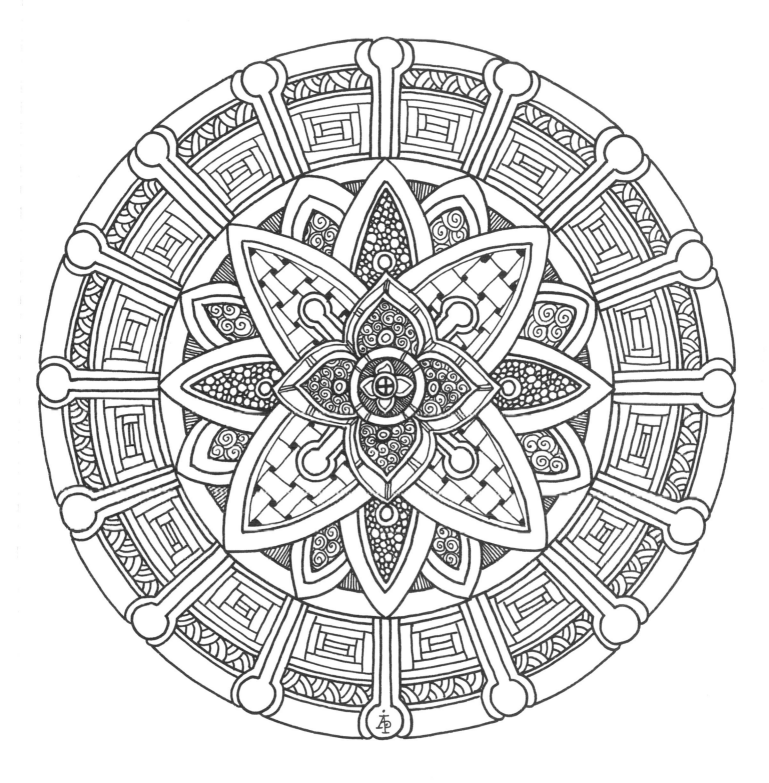

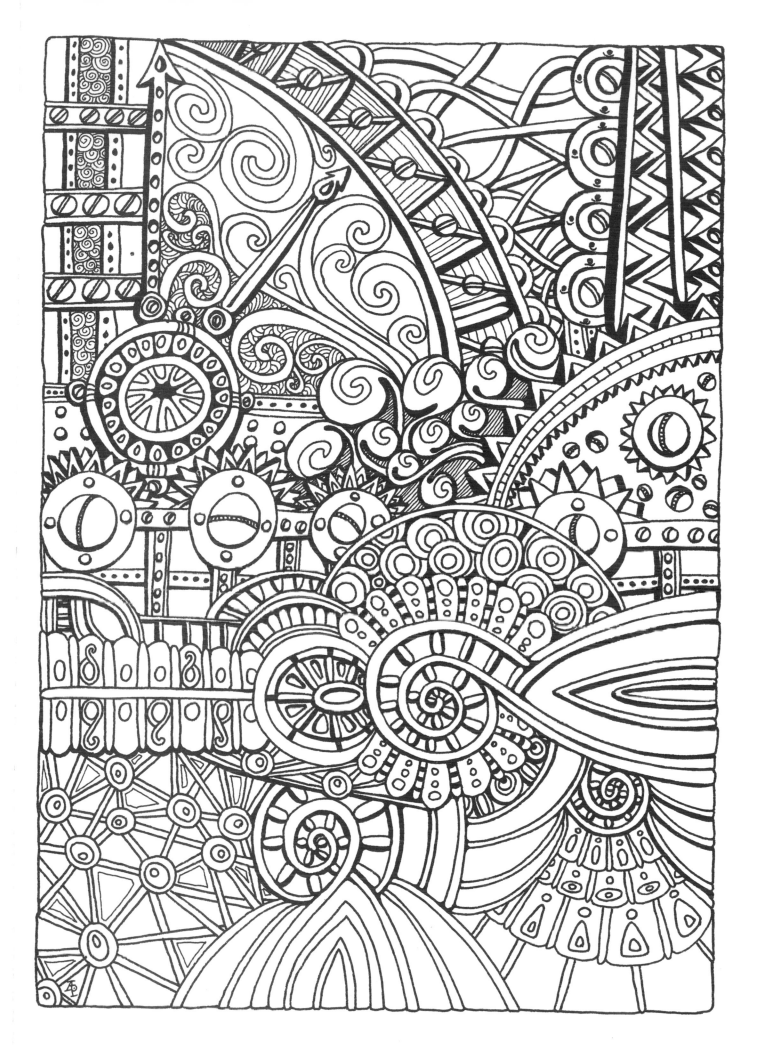

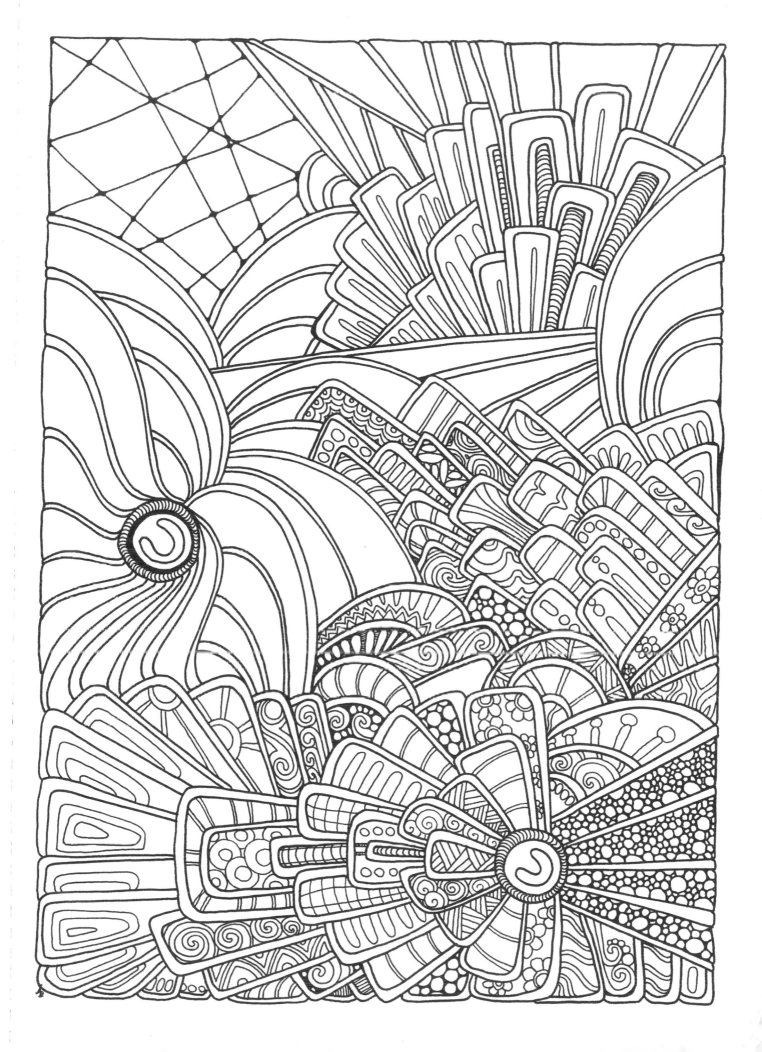

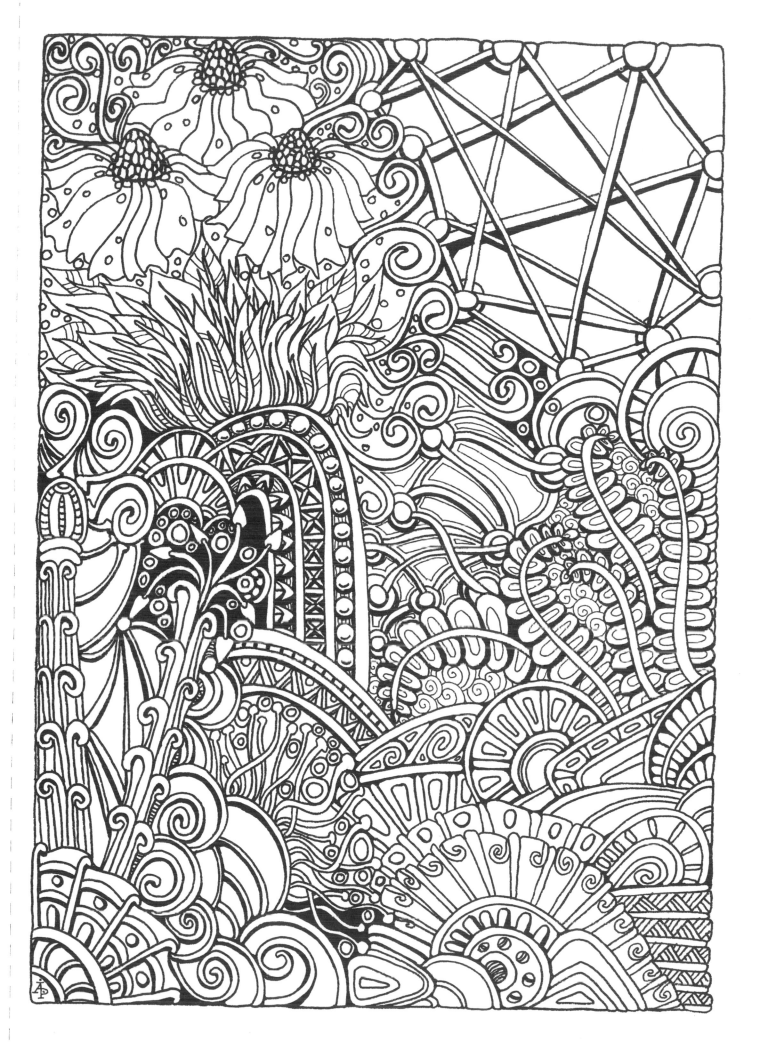